# COLOR
# SECRETS

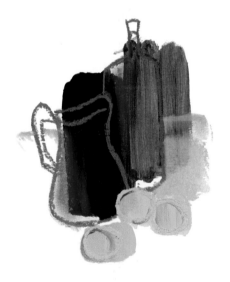

## Color Secrets

First English edition for the United States and Canada published in 2011
by Barron's Educational Series, Inc.
© Copyright 2009 by Parramón Ediciones, S.A.—World Rights.
Published by Parramón Ediciones, S.A., Barcelona, Spain.
English translation by Michael Brunelle and Jone Laura Brunelle

Original title of the book in Spanish: *El secreto de los colores*
Text: Gabriel Martín Roig
Exercises: Gabriel Martín, Óscar Sanchís, Glòria Valls
Photography: Estudi Nos & Soto, Gabriel Martín

*All inquiries should be addressed to:*
Barron's Educational Series, Inc.
250 Wireless Boulevard
Hauppauge, NY 11788
**www.barronseduc.com**

ISBN: 978-0-7641-6442-2
Library of Congress Control
    Number 2010940738

Printed in China
9 8 7 6 5 4 3 2 1

FEBRUARY 2012

# COLOR SECRETS

# Contents

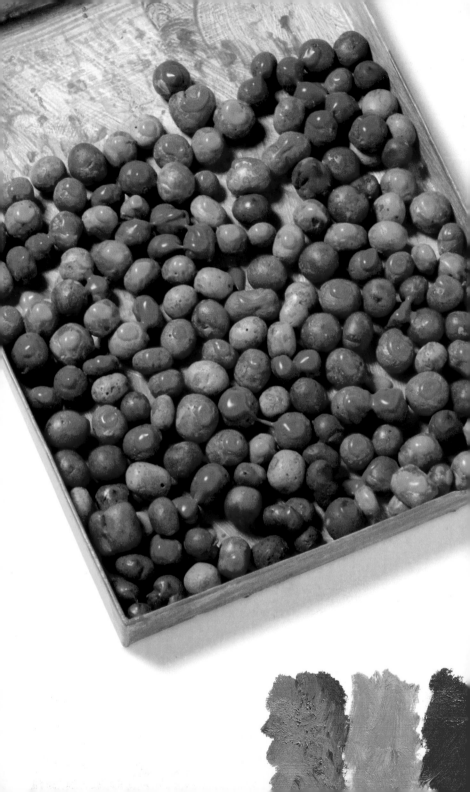

# Color in Context

Colors, present in everything that surrounds us, do not just serve to differentiate or decorate, but can also be thought of as a means of communicating messages and expressing feelings. They are most important in paintings; there, they are the element that attracts the eye. In the pictorial environment color develops all its potential and richness when combined and mixed. Colors are also responsible for blending the objects or figures that make up a painting into a whole, for making things stand out, or look bigger, and for making a background recede or come closer. There is practically no defect that cannot be disguised, or any element that cannot be accentuated using color.

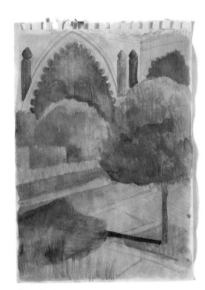

Knowing color and using it well is essential for any artist. The success of a painting and its potential for attracting the attention and surprising the viewer depends on its coloration. Therefore, controlling the combinations of colors in a painting creates an opportunity to increase the artistic and cultural value of the project, to enhance the best brushstrokes of the painting, and to give the objects the necessary emphasis.

In the following pages, we will analyze each fundamental technique for using color based on existing systems of classifying them.

We will also look at the physical and physiological principles on which we base the phenomenon of chromatic perception. We will also study the ways that color can be applied, based on the different techniques and the psychological and emotional effects one wishes to impart. From the utilization of correct colors to achieve a desired plastic effect, to original and modern ways of applying them all color theory will be covered.

In short, this book offers a valuable and up-to-date synthesis of theory and investigation of the different chromatic effects that can be found in a painting. Its goal is to reveal these secrets of color to you, the artist.

# Basic Information About Color

Color must be understood as an abstraction, like a basic starting point that can create a universe of sensations when united or combined with other colors. Colors from all the ranges of the spectrum can be developed, interestingly enough, by mixing the three primary colors (magenta, cyan, and yellow), from which come the secondary colors (orange, green, and violet). If you expect to understand and manipulate colors, first you must know the basics; that is achieved by studying their origin, their normal order of presentation, and their most effective mixtures and combinations.

THE SUBJECT

# Simple Color Theory

Our knowledge acquired in school about colors is based on basic or primary colors. It derives from the tradition of the historic French Academy of Painting, which taught that mixing the three primary colors makes it possible to produce every other color. It is essential, then, to know the possibilities of the primary and secondary colors, as well as anticipate the various results that can be obtained with pigments of different tones.

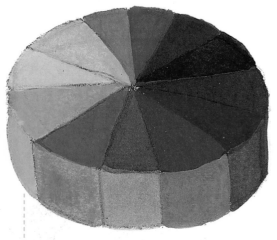

*Tertiary colors are created by mixing a primary color with a secondary color.* Thus, by mixing cyan and magenta with violet, you get a multitude of colors forming a wider and richer range.

**To create a color wheel,** divide a circle into twelve equal parts and organize a spectrum of primary, secondary, and tertiary colors within it.

*In theory, you create black by mixing the three basic colors;* in practice, the result is an intense brown.

## The Color Wheel

One of the simplest and most effective ways of organizing colors on a plane is with a color wheel. This wheel is made up of the three basic colors: magenta, yellow, and cyan. These colors are considered absolute, or primary, because they cannot be obtained through mixtures. When they are mixed together in equal parts, the secondary colors emerge (orange, green, and violet). Similarly, the mixing of a primary and secondary color creates a tertiary color. If you apply this theory to the six colors you have obtained, the result is a color wheel with twelve colors.

## Mixing All Colors

The mixing of the three primary colors is thought to create black, but in practice it is not so. Instead you will create a dirty dark brown, with little definition. This is not a bad thing, since for shading black is rarely used.

## Harmonic Shadows

To shade a color you use its complementary, which is to say, its opposite on the color wheel. Therefore, to paint the shadow of an orange object, you should mix orange with a little bit of blue (its opposite color). This way the tone that best harmonizes with the object's main color is achieved.

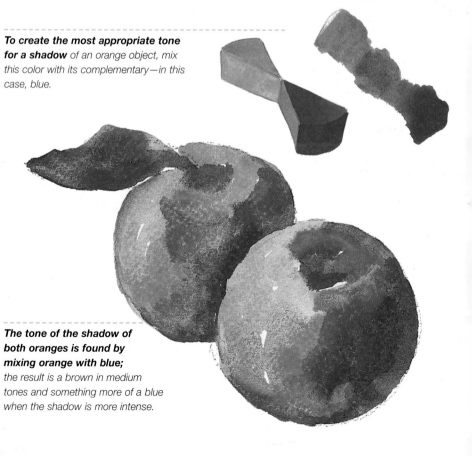

***To create the most appropriate tone for a shadow*** *of an orange object, mix this color with its complementary—in this case, blue.*

***The tone of the shadow of both oranges is found by mixing orange with blue;*** *the result is a brown in medium tones and something more of a blue when the shadow is more intense.*

# Color Is Form

THE SUBJECT

Form is distinguished because of color, and any element that is seen as a form cannot be separated from color. How do we distinguish colors? A group of cones in our retinas specialize in detecting and processing colors, and the cells work with the wavelengths of each color. Then, the process of identification of colors depends on the brain, which measures the wavelength of each color and translates it into a visual image, which forms in the brain and not in the eye.

*The colors used in this illustration show the same texture and tone;* however, the different wavelengths of green and red are what make the form of the object recognizable.

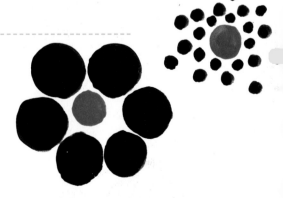

*These two blue circles are exactly the same;* however, the one on the left seems smaller in size when surrounded by other larger circles. This is proof that form does not depend on itself alone; the colors and forms that surround it affect it as well.

## Large and Small Objects

In a scene it is normal to see large, simple elements against a background of other smaller and more detailed ones. The large elements capture our attention first and appear closer. Color also contributes to bringing out the forms and principal motifs of the painting. However, be careful, you cannot ignore what surrounds the principal form. Color and form do not depend solely on themselves.

## Small Areas of Chromatic Color

The idea that the smallest thing is always least significant is wrong; in many cases, the smallest thing in a painting ends up dominating the scene. A painting can be composed using the effects of chromatic repetition: the gradation of brightness and the saturation can indicate the direction of movement or give the impression that the forms are receding.

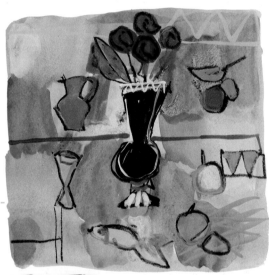

*The central object appears larger. It gains more importance when surrounded by objects and areas of color that are relatively smaller.*

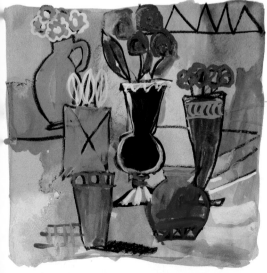

*Conversely, the central object loses prominence and strength when it is surrounded by objects with similar proportions and brighter colors.*

# Form and Background

Colors distinguish forms and distance them from backgrounds. This is achieved by contrasting colors that are far from each other on the color wheel, or by juxtaposing different amounts of luminosity of a single color. When a strong color contrast is used between the object and the background, a form appears clearly even if it is represented with only a light or blurry outline.

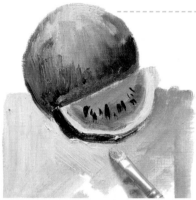

***Forms are normally represented by painting the object with a darker tone or color than the white canvas.*** *This allows you to gradate the shading on the model.*

***The same object against a dark background appears more illuminated,*** *which makes it necessary to intensify the shading of the model to reduce the contrast with the background.*

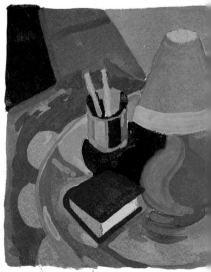

***To clearly identify the form*** *of the table lamp painted in warm saturated colors, paint the background with cool colors.*

## Relating Figure and Background

The colors of figures are often brighter and more saturated than their backgrounds, but the human eye is more accustomed to perceiving dark elements against a bright background. This does not always have to be this way; if you noticeably darken the background, the contrast actually highlights the form, although the amount of luminosity of the object needs to be adjusted. Light figures on a dark background appear to stand out from the shadows; they seem to advance toward the viewer and have a greater feeling of volume.

## Emphasizing a Form

Contrast is the main tool for bringing an object off of the background. For example, an element painted with warm colors is highlighted over a background of cool green and blue colors. A form painted with very light values is silhouetted best over a dark background. However, if you are trying to create maximum contrast and give the greatest effect of expansion of the form, two complementary colors must be juxtaposed.

*An object painted with a range of yellows, ochers, and reds* easily stands out from a blue background.

*When the colors of an object and the background are the same,* the contrast should be of values, that is to say, a light blue form will clearly stand out against the darker blue.

*The maximum contrast of a form* is achieved by juxtaposing two complementary colors.

# Chromatic Composition

Many artists use chromatic composition to emphasize certain parts of the painting so that the observer is drawn to those areas. This is achieved by organizing the colors in a way that directs the eye to the surface of the painting, or by attracting attention with contrast.

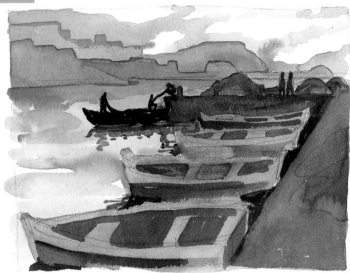

*One way to chromatically organize a composition is to* group large areas of the painting with the same color or with a chromatic range that unifies them, in this case violet.

*The tonal sequences that are gradated* from a saturated color to white suggest order and depth.

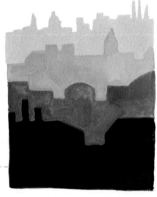

*A chromatic sequence, or tonal value scale, is often utilized in urban or natural landscapes.* The intensity of color indicates the distance of the image from the viewer.

## Working with Color Sequences

It is good practice to direct the viewer's eye. This is a matter of organizing the colors based on a color value scale, beginning with the darkest in the foreground and ending with the lightest in the distance. Psychologically, the natural order of understanding space is from dark to light, and not the other way around; otherwise, instead of suggesting depth, the painted form will tend to project from the painting in a disconcerting way.

## A Contrasting Color

In paintings with a range of similar harmonic colors, which create homogeneity, it is beneficial to introduce a counterpoint, or a note of very contrasted color, to attract the eye. This color counterpoint can be as contrasted as you like, but it should be limited to a small space in the painting, or it will lose its effect of surprise.

*Contrast is useful for directing the eye of the viewer.* In this watercolor, the contrast is situated in a group of trees, diverting the gaze from the natural focus of attention, which would otherwise be the church.

**When an area dominated by one color range breaks the chromatic monotony with a bright contrasting color,** it creates a counterpoint or focus of attention that powerfully attracts the viewer's attention.

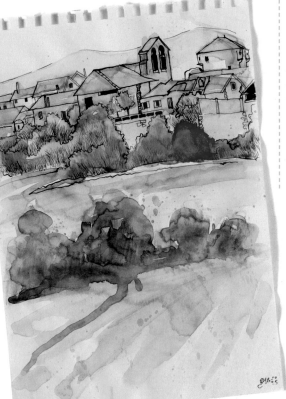

# Synthesizing Color

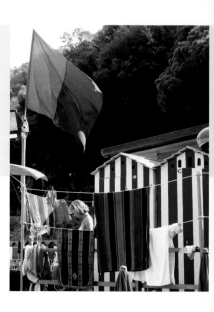

*The subject is a corner packed with geometric forms and rich contrasts. It does not have very obvious figurative elements and it can be seen as an abstract painting composed of a puzzle of geometric forms. This exercise is by Glòria Valls.*

**1**

**2**

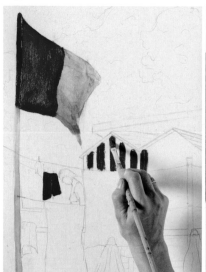

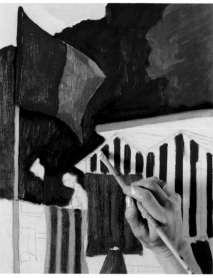

**1.** *Outlines without much detail are drawn in pencil to define the forms: the bathhouses, the towels, and the flag. Each part of the painting is brushed in with flat but bright colors.*

**2.** *The background of trees is created with just two tones of green, without gradations or blending. Everything is done in a very synthetic or stylized manner. The intention is not to imitate reality, but rather to transform it in the painting. A simpler reality than that in the models is achieved.*

The scene below is painted by synthesizing colors, that is to say, by combining each part of the painting that have colors that are more or less the same. In fact, this is a color study, experimenting with the possibilities of color as an element of pictorial language, with the intention of liberating it from its links with reality. The objective of this exercise painted with oil is to celebrate the color and the unique shapes, forgetting about textures and details.

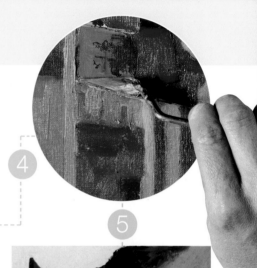

*3. The brushstrokes are added to the flag, working with two tones of blue to indicate its fold. The colors on the towels are more uniform. The flagpole is painted with a single continuous brushstroke. The colors should be applied only slightly mixed to give it a warm feeling and to stimulate the viewer's emotions.*

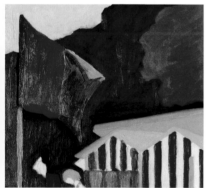

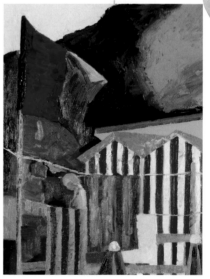

*4. Impastos are added with a palette knife, avoiding all imitation of nature. The treatment of the figure is a good example, even though the subject matter of the painting is real. It is painted very stylistically, so that the applications of strong impasto paint dominate, solid and strong, concerned only with color relationships and chromatic harmony.*

*5. Use the palette knife and brush to add more yellow to the vegetation and sap green to darken the color that surrounds the buildings. Use a flat palette knife to drag streaks of color on the towels, a treatment that differentiates them from architectural elements.*

# Pablo Picasso
## (1881–1973)

*Picasso dedicated more than four years to studying the possibilities offered by the harmonic range of blues.*

**Old Jew and a Boy,** *1903.*
*In this piece, Picasso exhibited the human drama of poverty with a sentimentalism transmitted by the blue chromatic range. He distorted the figure imaginatively to represent the moral and physical despondency of his characters.*

BLUE,

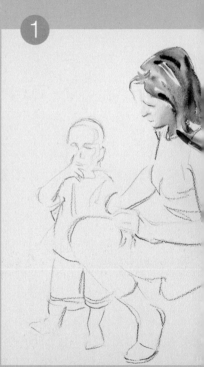

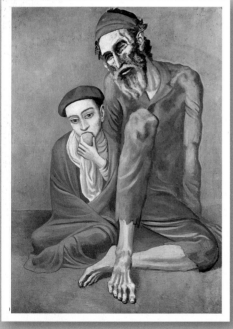

*1. This watercolor, painted by Óscar Sanchís, is inspired by the paintings from Picasso's blue period. The model is two figures, mother and son, sketched with simple lines done in blue pencil. He starts with the mother's head, where he mixes three blues: cyan, ultramarine, and Prussian.*

From 1901, while the artist was in Paris, he embarked on what is now called the blue period. Blue ended up taking over his paintings, after a brief struggle with greens and ochers. The different blues, intense, opaque, whitened, and thick were the great protagonists of the paintings; with these he created a compelling atmosphere with an immense expressive force. These paintings are proof that contrasts of loud saturated colors are not essential to transmit strong chromatic feelings. Picasso utilized blue for more than four years, and during this period his paintings became increasingly monochromatic.

## THE GREAT PROTAGONIST

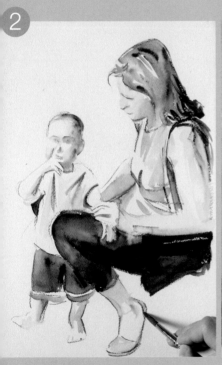

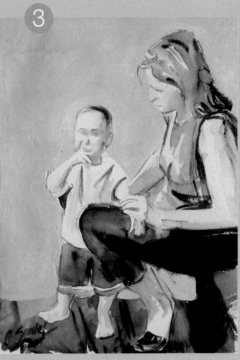

**2.** *Cyan is present in the outline of the figure; ultramarine is very diluted in the background. Use Prussian blue and a bit of Payne's gray to indicate the darkest zones of the hair and the pants. Do not add white; instead, dilute the color in water to lighten it.*

**3.** *The simplest relationships established with the blues are between analogous colors, although you can also use a bit of ocher, gray, or brown to create new blends of blue. This note of color has been achieved simply, with the final harmony of blues hinting at a general equilibrium or neutrality. So, it is important to avoid excessive contrasts, even among blues.*

# Synthesis and Color Schemes

In the same way you can summarize an experience or story, you can also concretize the image in a painting by eliminating unimportant details and generalizing others. This fine-tuning is known as synthesis, and it permits you to sum up the form in its purest state. To achieve synthesis, the forms are simplified and each zone is defined by large areas of paint that are more or less uniform.

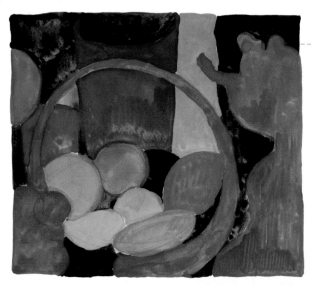

*The best way to synthesize is to simplify the colors of each zone.* Once the zones are identified, they are painted with even wash, without gradations and without trying to represent volumes. Here, the colors help to make up the basket of fruit.

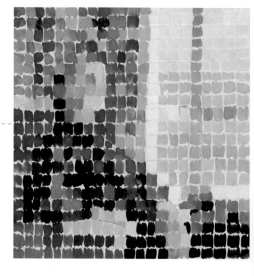

*This type of sketch is complicated to make,* but it allows for an exhaustive study of colors. First draw a grid on the paper and then paint each coordinate with the color in the real model. The result is a fragmented image of the model, but it has valuable chromatic information.

## Color Schemes

When the color sensations of a model are complex and varied, you can use a selective approximation of the subject, combining tones and organizing similarities to bring out the opposing colors in each zone. Distinct forms with schematic colors become good instruments for the analysis of contrasts, harmony, and the color relationships in a painting.

## Schematic Paintings
## with Saturated Colors

When saturated colors are in direct contact, the contrast is intensified. Imagine constructing a painting with saturated colors, pure tones, as if it were a puzzle of juxtaposed geometric shapes. The resulting painting will be a synthesis of the color sensations from the subject, and the integration of shape and color in a single system will be achieved with great economy.

*The repetition of colors and shapes in sketches creates a feeling of order in colors that would otherwise seem too bright and loud.* The repetitive color sequences, furthermore, give stability to the painting and prevent the eye from wandering aimlessly from one side to the other.

*In any real model, the colors are usually harmonic, with few color variations,* especially if it is a natural landscape. Working with saturated colors is a good way to stir up this harmony and calm atmosphere.

*Here is an exercise in synthesizing adjacent images;* the space is fragmented with small geometric shapes painted in vivid, saturated, even colors. Yellows, blues, reds, and purples are added over the greens—strange colors for vegetation, but they make sense when the general dynamic of synthesis in the painting is extremely colorful.

# Simultaneous Contrast

The perception we have of a color is influenced by what surrounds it. Because of this, the characteristics of a color are not absolute but relative to its environment. For example, any color seems lighter when it is surrounded by a darker color, and the same color seems darker when the background is lighter.

*The appearance of colors changes depending on the color of the background.* This effect is known as metamerism. The interior rectangles, which are the same color, look as if they are different colors because they are under the influence of two distinct adjacent colors.

*Because of simultaneous contrast,* the square surrounded by a lighter color will always look darker than the square surrounded by a darker color.

*Compare these two colors over a black background.* The yellow on the right, saturated and luminous, looks larger than the violet on the left.

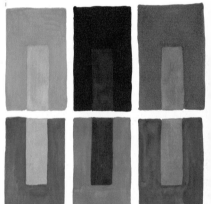

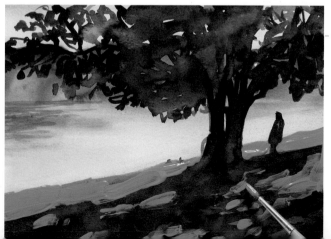

*To avoid simultaneous contrast,* the weaker color should be clear and saturated, so it seems to expand and become brighter.

## The Environment Affects Colors

A single color can seem very different depending on whether it is placed next to one color or another; this reaction is known as *simultaneous contrast*. The effect can be used to strengthen colors. However, simultaneous contrast only works in that small area surrounding the division between two colors; therefore, the effect can be reduced or eliminated by completely separating the color areas with a white or black outline.

## Reducing or Accentuating Contrast

A more subtle way to avoid the influence of simultaneous contrast on a color is by adding a small amount of complementary color to the weaker color. This way the artist can regain control of the chromatic perception and create a more controlled impression. However, the weak color is very saturated (that is brighter than its surroundings) this area will seem to expand and be larger than the colors adjusted with other tones. The most expansive colors, in order, are: yellow, red, blue, and black over white.

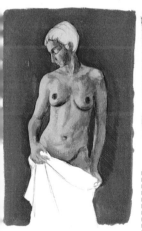

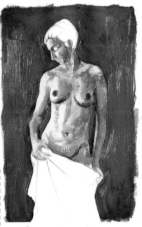

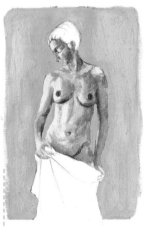

*A color can greatly change the way it looks depending on its surroundings.* In this figure, the coloration of the skin seems dull and greenish against a red background.

*In this figure, the skin looks rosier and even a bit orange against a blue background.* Thanks to simultaneous contrast, the color of the background casts its complementary color, orange, on the figure.

*The skin in this figure, surrounded by a very saturated yellow, shows a violet tendency.* All colors, no matter how intense, take on some of the opposite color of the background.

# Achromatic Colors:
# Black, White, and Gray

While chromatic colors are from the rainbow spectrum, the achromatic colors, white and black, are not. In a way, they can be thought of as "non colors." That is to say, they are neutral colors that do not form part of the color wheel. White is considered the absence of all color, and black, the opposite, is the equal mixture of all colors.

*Experimental artists who create monochromatic paintings* in the gray tones usually add a bit of other colors to gray to get different shades. This provides a great chromatic richness to the finished piece.

*White and black are considered achromatic* because they are not found on the color wheel. No color exists that is as dark as black or as light as white.

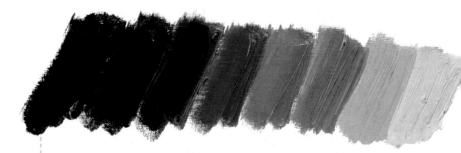

*A monochromatic sketch is based in one single color,* and the variations are created through the adjustment of brightness or saturation. The different tones are made with an unequal mix of white and black.

## Considering White and Black

From the point of view of physics, white is not a color but rather an absence of color. Because of this, most supports used for painting are white. White can be considered a primary color, since it is not possible to obtain it from any mixture. On the other hand, since black can be produced by mixing all other colors, it can be considered a secondary color.

## Working with Gradations of Gray

Mixing black and white pigments in varying proportions produces grays. These, together with black and white, are called *neutral colors*. By mixing, it is possible to obtain numerous grays; however, the most useful approach for painting is to create four or five, specifically a dark gray, a pair of medium grays, and two light grays. These five gradations, together with white and black, provide a sufficient base for a careful systemization of colors. The plane that includes these gradations is called the *gray scale*.

*In watercolor, distinct tones are not made by mixing black and white,* but by diluting the gray with more or less water. With three or four values the representation will be convincing.

# The Importance of Black in a Painting

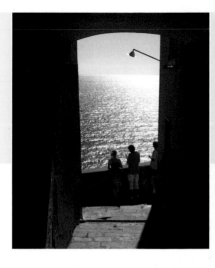

*The subject is an alley seen against the light, with the walls in the foreground plunged in a deep shadow.*

*1. Óscar Sanchís creates the drawing with a number 2B pencil. Before painting he has already ruled out using black, so the dark tones will be achieved with mixes of other colors. The first colors are violets, the result of combining dark ultramarine blue, alizarin crimson, and cadmium red.*

*2. Ultramarine blue is the base color of the shadows and will give cohesion to everything else. The darkness is not painted uniformly, but will be built up with thick brushstrokes of brown, gray, and violet. The most illuminated area of the wall is painted with pink.*

In a scene with little light, where shadows occupy the majority of the painting, the retinal cones do not capture the details and vision depend on the rods, which do not distinguish color wavelengths. Because of this, nearly everything is perceived as black. Is it necessary to paint these dark zones black?

Most colorist artists opt to convert the blacks of the shadows into colors that make the interpretation of the picture more attractive, without losing the contrast with the areas of light. In this exercise, done in oil, we show the conversion of the shadows.

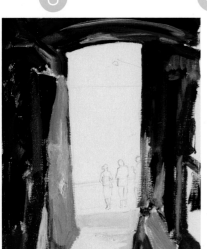

*4. The white paper, still visible in the walls, is finally covered with heavy brushstrokes of medium violet, gray, and blue. The brushstrokes are somewhat angled, following the beam of light that bursts in on the alley.*

*3. Applied around the arch are black brushstrokes obtained by mixing alizarin crimson, sap green, and dark ultramarine blue. Lighter tones, mixed with white paint, dominate the light parts of the wall.*

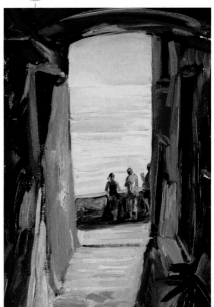

*5. The deepest blacks define the doors and windows in the walls. The range of blues and violets dominates the more shadowy parts, while browns and ochers are more frequent in the zones with medium shadows. The painting is finalized with the representation of the background illuminated with light colors; however, the most relevant part of the painting is the foreground and its use of colors in the shadows.*

# Color Harmony

Harmonizing colors means applying them in such a way that they relate to each other in a way that is sweet and smooth. Colors do not harmonize by themselves. There must be a plan for this to happen, some guideline established before beginning. Harmony is achieved when the colors of a composition are balanced, none standing out any more than the other, in a way that makes the work attractive and pleasing.

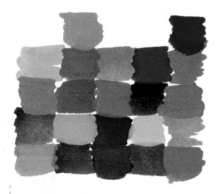

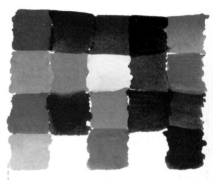

*In this composition the colors do not show any harmony.* *They are very different from each other, and far apart on the color wheel.*

*When colors are harmonic,* *there is a general common tone, and little contrast between them. They are analogous, or close to each other on the color wheel. Harmony gives greater unity to the combination of colors.*

*A harmonic landscape is one that has a common or general chromatic tendency,* *without excessive leaps between colors. This watercolor is held together by violet tones.*

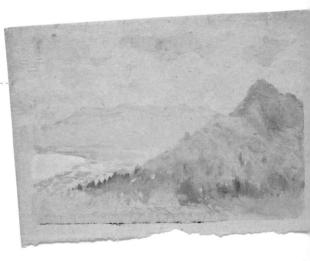

## Melodic Range

Melodic range takes a single color, usually a brown or blue, and mixes it with white or black to obtain a wider variety of tones. It results in a monochromatic painting, but the effect is convincing because it also makes use of rich shading. Mixing white and black with a single color might seem like a bad idea for a painting; but, considering the ability of white and black to make gray tones, their use in monochrome works can have beneficial results.

## Simple Harmonic Range

This refers to the use of one dominant color accompanied by three other colors of an opposite shade. Through mixing, these colors form a group of new colors that harmonize with the initial color.

*To paint this tone* with a simple harmonic range, use a blue that varies when mixed with white and black.

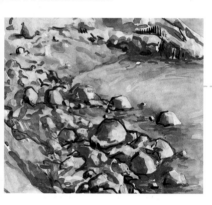

*This rocky area of a coast was painted with blue watercolor and white and black gouache.* All the tones of the rocks were made by combining these three colors. The paintings were created with a simple harmonic range that can be considered monochrome.

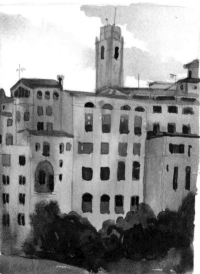

*A simple harmonic range is developed from this other note of color.* The dominant color is ocher, which is mixed with three different blues to obtain a wider range of tones and blends.

*The mixing of ocher with three blue tones offers great chromatic possibilities,* maintaining a harmonic representation without chromatic jumps. None of the colors clash; they are all perfectly integrated.

THE SUBJECT

# The Temperature of Colors

The chromatic effect of a color depends on its temperature. If a color seems warm, the quantity of yellow and red that it contains is intense, but if it seems cool, there will be predominantly blue or green radiation. This division of colors into warms and cools is based on the thermal sensations that they transmit. Before painting a subject, think about the sensation you want to impart to the viewer. Which will dominate, cool tones or warm tones?

*Warm colors are present in fire. They transmit a sensation of energy. They go from red through orange to yellow.*

*Various notes of color painted within a warm range. These tones, when saturated, suggest a fiery sensation, and radiate energy and strength.*

## Warm Colors

Warm colors go from reds to yellows and include any tones that are reminiscent of fire. Think of a hot summer day. The sunlight that bathes the scene hints of ocher, red, and yellow. Warm colors have a stimulating effect and create a sensation of activity, happiness, and dynamism. They can also create the impression of closeness, with the surface of the painting seeming to advance toward the eye.

## Cool Colors

These colors range from blues to greens, and include some violets. Think of a frigid winter day. The gray, blue, and pale colors evoke the cold, but they also create a feeling of tranquility and seriousness. Cool colors can produce a receding effect and the feeling of movement is relaxed or still. Cooler colors suggest distance rather than nearness.

## Juxtaposition and Mediators

The juxtaposition of both ranges is called *cool-warm contrast*, and it is very typical in paintings. Green, magenta, and violet are *mediating colors*; green tends toward cool colors, magenta toward warm colors. Violet is between the two temperatures, and depending on the amount of blue or red it contains, it can lean toward one side or the other.

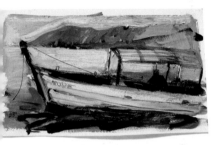

*The areas painted with the cool color range appear somewhat lifeless* and less bright, but they create an interesting harmony between all zones of the painting, with no abrupt changes.

*Cool colors are used in the vegetation and water.* The use of blues and greens create a cool feeling.

# Knowing the Colors on Your Palette

The names of colors often tell us about their psychological impact on the painter, their place of origin, or the mineral from which they are obtained. Manufacturers know that the names of the colors on the chart grab our attention more readily than the pigment names. In painting

*Cadmium yellow is an essential color to every artist's palette. Avoid mixing it with black, or you will get an unappealing green.*

*Cadmium red is one of the most expansive and saturated colors in existence; it is essentia for painting bright pieces. It is usually lightened with orange instead of white.*

*Ocher is a fundamental color for lightening green and earth tones. It should be used instead of white.*

*It is a good idea to equip yourself with two or three brownish-grays or distinct earth tones, particularly if you are painting landscapes. Combining these with black and carmine is customary in creating a wider range of colors.*

manuals you will find brief notes about the importance of each color, emphasizing their characteristics and ability to combine with other colors. Let's take a look at some of those principles.

*Rarely will you encounter black paint on an artist's palette. It is usually made by mixing alizarin crimson, Prussian blue, or ultramarine blue with sap green.*

*Cobalt blue is a favorite of many artists, but it is a good idea to use all three basic blues: cobalt, ultramarine, and Prussian blue. Ultramarine is the warmest and Prussian blue is the coolest.*

*Medium intensity greens seem loud and unsuitable for painting vegetation. It is important to reduce them by mixing them with a color like ocher.*

*Sap green is one of the darkest of the greens. You can use it to darken other greens; dark ultramarine blue can be used for this as well.*

*Violet is not an essential necessary color, but those who make very colorful paintings like to have it on hand. The color purchased in the tube is brighter than violet made by mixing.*

*Alizarin crimson is fundamental in making oranges and pinks. It is a good complementary for darkening brownish-grays and adding warmth to blues.*

# Landscape: Creating Distance with Color

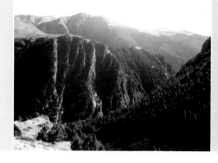

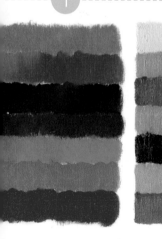

*This simple landscape, with several overlapping planes, is the departure point for this exercise by Gabriel Martín.*

*You must use colors in the correct order to complete this exercise. If the colors of the real landscape do not coincide with those of the sketch, they should be altered so they can be more like this example.*

**1**

**2**

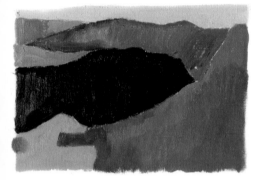

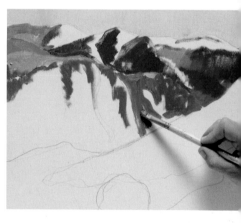

**1.** *Prepare a range of colors that will be applied in each plane. The farthest mountains will be blue tones, while the greens will be increasingly warmer as they move closer.*

**2.** *Following the sketch, fill in the farthest mountains with somewhat lightened blues and violets. This will highlight the features of the real model. The lightest hillsides are painted next and then the middle plane is covered with an intense green.*

Some colors express distance and others are more appropriate for the middle planes or foreground. In the sketch we indicate what the order of colors should be according to their distance: the warm colors in the closer planes and the blues in the farther ones. This can be confusing, since the difficulty lies in applying this color technique to a real landscape. In this oil painting exercise we will show you how to get started.

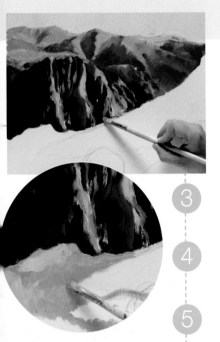

*3. In the middle plane, apply very dark green brushstrokes over the previous colors to distinguish areas of vegetation and rocks. Using a grayish white and vertical brushstrokes we paint the rocky cliffs.*

*4. An ocher meadow is painted using this same color, but with somewhat more yellow in it. Compare this area with the meadow on top of the mountain behind it, which has a bluer ocher.*

*5. When painting the closer forest, the greens should be lightened with yellow. The painting is finished with very loose areas of color with few details, following the predetermined order of colors in the sketch.*

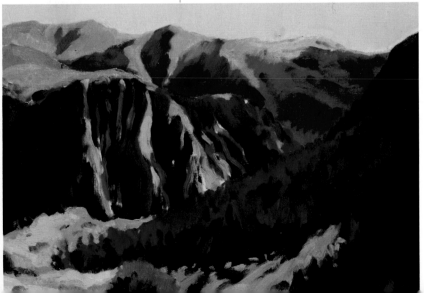

# William Turner
(1775–1851)

William Turner was one of the most prolific Romantic painters. He traveled around Europe with his watercolors, in search of pastoral landscapes and sunsets with dramatic atmospheric effects.

*1. To emulate the style of Turner, Gabriel Martín starts with a dry brush, without diluting it in thinner. Rather than starting with an initial drawing, he goes to work directly with the brush. He suggests distant mountains using brown brushstrokes and he paints the sea and the sky with blue.*

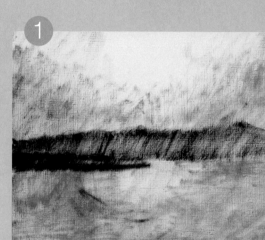

PAINTING
THE LIGHT IN THE LANDSCAPE

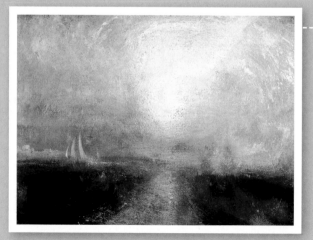

**Yacht Approaching the Coast, 1835–1840.**
*Turner created a seascape with the sun low on the horizon using ocher, brown, and white blends and brushstrokes. On the left is a sailing ship nearing the port. The gradations and fusion of brushstrokes are very important in representing the atmosphere here.*

In his oil paintings, he attempted to reproduce the changeable effects of light on the landscape, that is, the force of nature, with brushstrokes that dissolve the forms. To represent the landscape and the natural forces that they dominate, the artist uses color and applies it in a way that almost avoids figurative painting, in a bold foray into the field of abstraction. His style greatly influenced the Impressionist artists.

**Self-Portrait, 1798.** *William Turner anticipated Impressionist brushwork in his paintings, by capturing light through his use of color.*

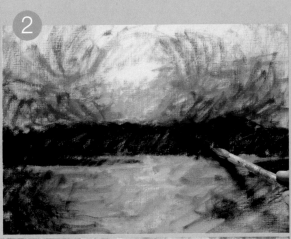

*2. The distant mountains are darkened with new brushstrokes of dry paint. The sky is brightened using cadmium yellow and cadmium red. It is covered with brushstrokes of these warm colors. The central space, which will be occupied by the sun, is left blank.*

*3. The brushstrokes accumulate over each other, with new additions of gray, Naples yellow, and white. Little by little the surface of the canvas will be covered in colors that will finally be blended with a clean, dry brush, by lightly stroking the surface.*

# Why Does Blue Seem Far Away?

Blue light is dispersed in short waves. It refracts and reflects the water vapor and dust suspended in the atmosphere. The decoloration and bluishness that is perceived in the distant planes of a landscape are due to atmospheric humidity. Paul Cézanne wrote about the need to introduce a "sufficient number of blues to give the air feeling" in the waves of light. This is perspective without lines or vanishing points; the third dimension is created instead through color gradations.

*Depth is created in a composition by lightening the colors of elements as they move away from the primary plane.*

*The farthest planes of a landscape become blue because of the atmosphere.*

*The effect of depth in a landscape can be summed up with this gradation, with the persistence of blues in the upper parts and the brown-grays at the lower parts.*

## Distant Colors

Because of the effect produced by the atmosphere in landscapes, today we tend to expect blue, violet, and gray tones to occupy the farthest planes in a landscape. Psychologically, they transmit the impression of distance. This principle is often applied to other genres of painting.

## Bleaching of Colors

What happens when reds or oranges are distant? Just like blues, they become increasingly lighter. Thus, in a still life the objects in the background should be painted with lighter and less saturated colors than those in the foreground, and with less distinct outlines. The illusion of depth is achieved by making background objects appear mistier, less sharp, and lighter than the closer objects. This contrast reinforces the impression that the forms are far away.

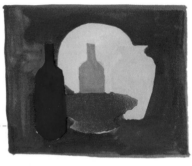

**The effect of lighter objects** in the background contributes to the impression of depth in a still life.

*Objects in the foreground appear concise and are painted with dark tones; those in the background show less detail, and have lighter colors and blurred outlines, as if the objects were out of focus.*

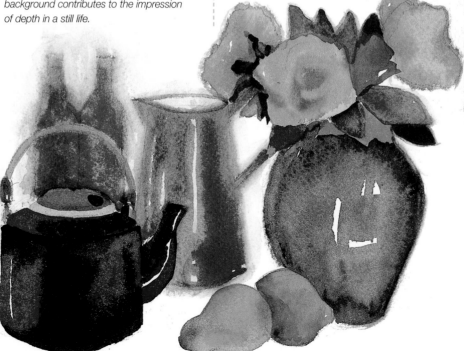

# Seeing and Feeling Colors

**Learning to differentiate one color from another** and classifying colors within specific groups or ranges in a more or less rational and scientific way is part of the apprenticeship of all artists. However, this is not enough. An artist must also learn to appropriate and internalize color, to convert it into feeling, into an expressive tool. The process of identifying colors in a model melds with another process—one that attempts to sift, modify, and alter colors with the goal of imparting to the painting some of the feelings and personality of the creator. This work can sometimes be confusing, so in this section we reveal some tricks of the trade and some strategies to successfully carry them out.

THE SUBJECT

# Learning to Capture Colors

When you paint a naturalistic subject, you do not necessarily have to adjust the real colors of the model nor be faithful to them to the extreme. Of course, you should hone your observational skills—however, the beginning artist can be hindered by his or her limited training in this area. Lacking confidence and daring, many novice artists concentrate on reproducing real colors without modification.

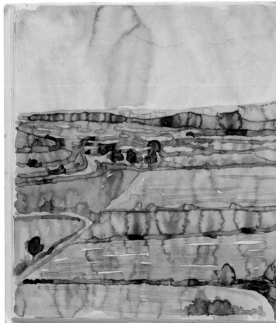

*You do not have to be subtle when painting the greens in vegetation.* Here we have a group of green tones that are not very contrasted; if they are spread across a landscape it will look smoother without the contrasts.

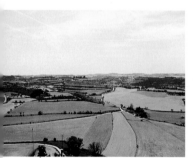

*This model presents a problem for the artist:* All the wheat fields look the same color, and the same goes for the vegetation.

## Modification Is a Must

One must not only copy, but also interpret, especially when the real colors in a model can create confusion. Suppose we are painting a landscape, either in the field or from a photograph, where the variety of greens is limited. You will have to add different touches of blue, ocher, red, or brownish-grays so that the greens look more varied and each plane can be clearly distinguished.

## Moving from Subtlety to Evidence

When you capture a color, you have the opportunity to slightly modify it, to pass it through your personal filter in order to make a more sensible painting. To modify a color, you must isolate it and try to predict its tonality. Ask yourself whether it has a bluish, greenish, yellowish, or some other tendency. Then you might strengthen it by adding a greater quantity of the color perceived in the shade. For example, if you feel that a brown seems greenish, you will add a little more green to the painting so that this tonal subtlety becomes more obvious.

*To make variations of color stand out better, mix a greater quantity of other colors with the green.* It doesn't matter that some greens morph into oranges, blues, or ochers.

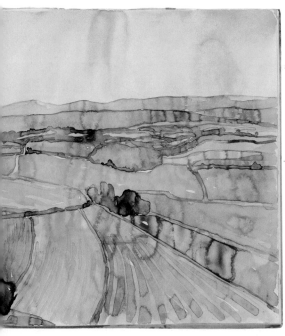

*When a model seems chromatically monotonous,* you must modify the real colors. Here, each wheat field should feature a different color to be distinguished from those surrounding it. This way, the final painting will offer a greater variety of color.

# Feeling and Interpreting Colors

Faced with the same model, every artist will create a different painting made up of different colors. There are two reasons for this: we do not all perceive colors the same way (where I might see blue, you might see green), and each of us has our own distinct interpretations based on our experiences, personalities, and sentiments. True artists appreciate that works of art are understood according to the way each viewer feels, since this diversifies and enriches their works.

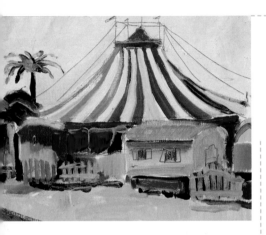

**The subject is a view of a circus tent.** *In the preliminary version, the blue is prominent. The stripes and all the shadows of the wagons are painted with this blue and violet. The illuminated zones are painted with the real colors, but somewhat more saturated.*

**This second version is a little more complex.** *Each zone is painted with its opposite color from the color wheel. That is to say, if the sky is blue, it is painted with orange, and so on with all the colors. The subject will end up with a look that is far from realistic, but will not be any less attractive because of it.*

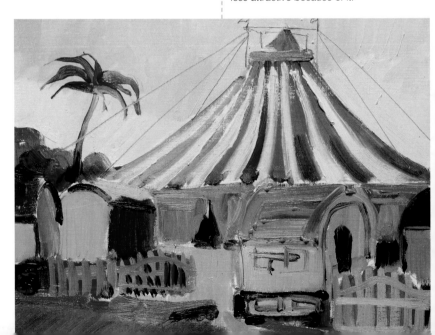

## Addressing Subjectivity

Conscious subjectivity refers to the interpretation of form, color, and premeditated contrasts to create a deliberate effect in order to illustrate a particular way of perceiving things. Color becomes another of the artist's instruments of expression. The actual colors in a model should not be copied precisely; in fact, a good artist will enliven a painting by making use of his own original range of colors—one that reflects his own personality and style. Chromatic harmony is subjective; therefore, after a period of experimentation, artists tend to develop customized, personal palettes.

*In the final example, the colors of the actual model are observed and indentified, and then transferred to the canvas in a brighter, more saturated way. This means that, the colors of the painting are the same as in real life, but they are brighter, more expansive, and more contrasted versions. This produces a painting with exaggerated and exciting coloring.*

## Ways of Modifying Colors

There is no single template for art interpretation; however, we can provide the experimenting artist with some advice on how to modify colors in an actual model to create a more attractive work. Here we show how to interpret a subject with three simple chromatic processes, which result in three distinct color combinations.

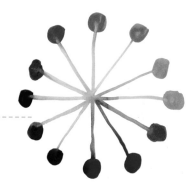

*To make the work simpler and more effective, just make a sketch that shows the opposite colors on the color wheel.*

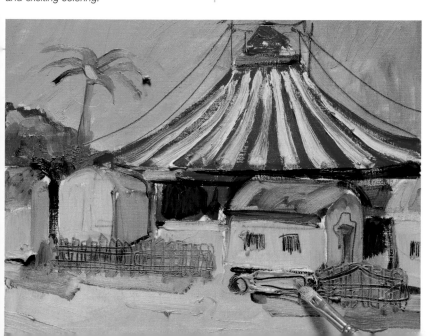

# Chromatic Effects: Help from the Computer

For artists who have difficulty transforming and inventing original combinations of color from the real model, new technology can be a helpful tool. Bitmap programs, like Photoshop®, can manipulate colors

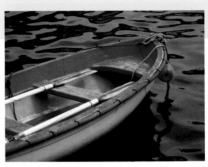

*Here a tightly framed image of a small boat, in which the simplicity of forms prevail.*

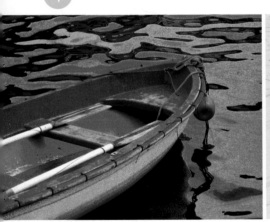

**1.** *Modern technology gives the artist (here, Óscar Sanchís) new methods to transform models, as shown in this photo modified via Photoshop. These computer resources can be thought of as an extension of the artist's palette.*

**2.** *The picture is drawn with a 2B graphite pencil. It is simple and linear, and it is quite similar to the model. After sketching, the water is painted in a medium saturated green, with very little mixing. The paint is flat and opaque.*

in digital photographs in many different ways. The tone/saturation menu allows the three properties of color to be adjusted. By moving the bars, you can change the definitive color of the image, transforming it into a chromatic combination that has nothing to do with reality. Sliding another bar will modify the saturation so the colors look more or less bright. Óscar Sanchís created the following exercise with acrylic paint.

*3.* *Once the illuminated areas of water are covered with green, the shadows of the boat are painted with ultramarine blue. To create the violet-blue variations, it is mixed with a bit of crimson.*

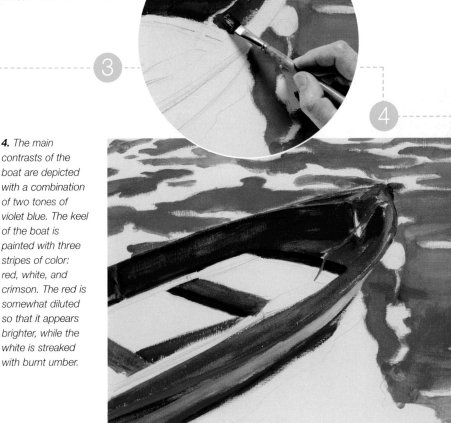

*4.* *The main contrasts of the boat are depicted with a combination of two tones of violet blue. The keel of the boat is painted with three stripes of color: red, white, and crimson. The red is somewhat diluted so that it appears brighter, while the white is streaked with burnt umber.*

**5.** *Rapid drying acrylics prevent the red and blue from mixing; this way, the colors appear to have a heightened level of saturation. Diluting the red makes it more transparent, and the white of the paper causes the color to be more luminous than the adjacent colors.*

**6.** *Violet mixed with burnt umber is used to paint the dark reflections on the surface of the water. This produces a strong contrast between the dark, gloomy violet and the bright, lively green. The application of color is not completely smooth; subtle variations of color are produced in each area by adding more or less water to the mixture.*

**7.** *A green similar to that used on the surface of the water is painted in the illuminated area of the boat's interior. A bit of cardboard as a stencil is used to avoid accidentally painting the blue bench, and it also ensures a straight and well-defined profile.*

**8.** *Only a few more details remain. The shapes of the oars are created with light violet and white, the ends are painted in, and some blackish-green shadows are applied to the interior of the boat. These steps happen once the previous layers of paint are dry.*

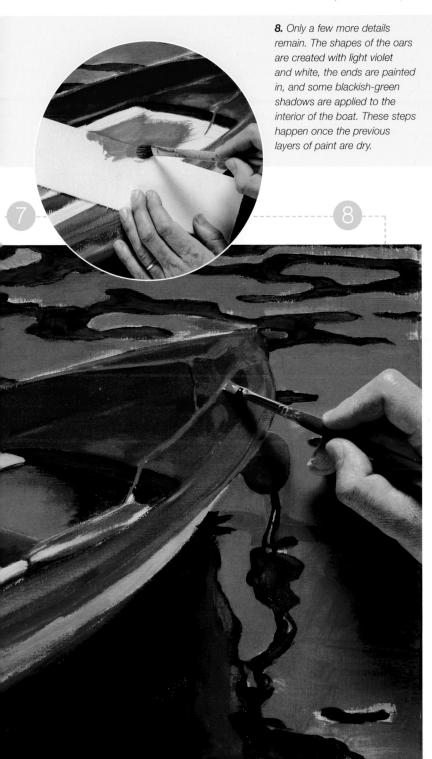

# Contrasts Are Key

Color contrast is important when you want to impart significance in a composition. Elements are highlighted more or less depending upon the differences in color or the amount of their contact. Contrast has maximum effect when one color is completely surrounded by another. For contrasts to function well, brightness, saturation, and extension of the selected colors should be adjusted until they have a similar visual intensity.

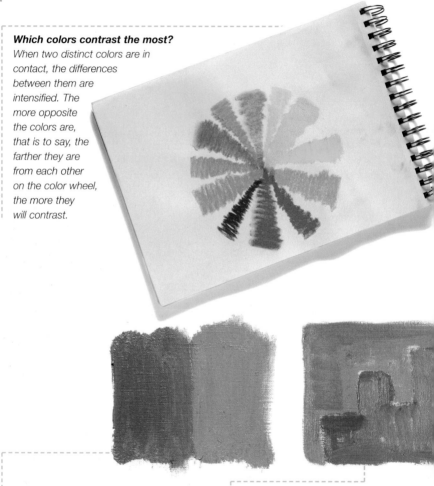

***Which colors contrast the most?***
*When two distinct colors are in contact, the differences between them are intensified. The more opposite the colors are, that is to say, the farther they are from each other on the color wheel, the more they will contrast.*

***When two very saturated and contrasted colors meet,*** *a struggle is created between them; a sort of mutual rejection occurs.*

***To mitigate the rejection between two colors*** *—so that they interact and relate better—let them intermix with their opposites.*

## Conflicting or Integrated Colors

When two light, saturated, and bright colors are placed side by side, both are mutually activated, producing a repelling effect. To soften this adverse effect, these two colors can be situated one inside the other. When one color chromatically wraps around the other, they interact better, and the contrast appears more integrated.

## Tertiary Contrast

There is a noticeable reduction in contrast among tertiary colors. The force of opposition of colors tends to decrease as more mixes appear in them. Although the contrast between tertiary colors is less striking, these less intense contrasts can help to harmonize a work in a controlled and effective way.

*The contrast between very distant colors* on the color wheel makes a strong impact that is expressive and energetic.

*Contrast is more effective* when the perimeter or area of contact between the two colors is quite substantial.

# Saturated Colors

The lightest and most luminous primary and secondary colors, used directly from the tube, are the most saturated, expansive, and radiant. That said, a single one of these colors applied in a large area can seem irritating or boring. When combined with less saturated tones they can, however, contribute variety and a dynamic feeling to a piece.

*Colors straight from the tube present a high grade of saturation since they are pure and unmixed.*

*Saturated colors are usually used to express light, while dull ones are perceived as areas of shadow.*

## Color, Chroma, and Saturation

Colors exactly as they are perceived with sight are denominated pure or *chromatic*. *Chroma* refers only to a generic idea of pure color—to a determined wavelength that clearly differentiates one color from another. In this way, we distinguish colors by their chromatic or generic names: red, green, yellow, orange. *Saturation* is the color's grade of purity. Chroma and pure colors, when they are included, are completely saturated.

## Desaturating Colors

The purity of a color is altered by any mixing. The most evident and radical alteration results from mixture with its complement. If you add a little green to red, it reduces saturation in proportion to the amount the complement that is added. As colors are mixed to form secondary or tertiary colors, the level of saturation is progressively reduced; therefore, the more grayed or mixed a color is, the less saturated it is considered to be.

*The saturated magenta line* makes the shapes stand out from the blackish and bluish areas of color.

*Qualitative contrast refers to the juxtaposition of two colors* with different levels of purity—specifically, the opposition between a saturated, bright color and second duller, weak color. Pure colors add vitality and greater interest to the whole.

# Methods of Color Desaturation

There are various ways to desaturate a pure color and each produces a different result. What they all have in common is the mixing of a color with white, black, and gray. This makes the saturation decrease and the colors evolve towards cool, grayed, or neutral tones. However, not all colors react in the same way; some are more sensitive to the changes and others offer greater resistance in changing their level of saturation.

You can desaturate a color with the help of white. Here, carmine red mixed with white becomes cool and loses strength.

With white, yellow becomes cooler. More white is required to desaturate yellow than is needed with red.

Blue is probably the color that stays saturated the longest when adding white.

Dark, saturated violet seems menacing, but after lightening it with white it evokes happiness.

Black increases the natural darkness of violet so much that its color can barely be distinguished.

Black paralyzes blue, and does the same to violet.

Red mixed with black acquires a brown or crimson tone.

Green is less sensitive to mixing with black and is more resistant to losing its saturation.

Generally, an insignificant amount of black or gray added to any color affects its luminosity and moves it away from saturation. In chromatic terms, it will deaden the color.

# The Color of Shadows

Shadows are traditionally the same color as the main object, although somewhat altered with brown or black. However, the decreased light does not necessarily require that the painter darkens or blackens the shadows. The contrast between illuminated areas and shadowed areas can also be represented using chromatic contrast. Thus, some artists opt to substitute the traditional dark tones with alternate lighter, more vibrant ones when painting shadows.

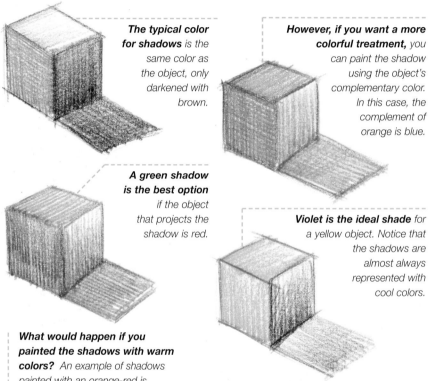

**The typical color for shadows** is the same color as the object, only darkened with brown.

**However, if you want a more colorful treatment,** you can paint the shadow using the object's complementary color. In this case, the complement of orange is blue.

**A green shadow is the best option** if the object that projects the shadow is red.

**Violet is the ideal shade** for a yellow object. Notice that the shadows are almost always represented with cool colors.

**What would happen if you painted the shadows with warm colors?** An example of shadows painted with an orange-red is shown here. The effect is somewhat disconcerting, since you cannot distinguish whether the adjacent white color corresponds to the zone of light or to the shadow. Therefore, shading with warm tones, which are generally associated with light, can make the painting confusing to understand.

## Blue Shadows

Since light is represented with warm colors like yellow, when it is not very intense it cools. As a consequence, light can become bluish or violet, which is exactly what happens with the colors of the landscape during dawn or dusk. In this case, the shadows are no longer areas of dark color—rather they become a color themselves, a complement to the most illuminated areas of the painting.

*__Many artists use blue to highlight shadows in a model.__ This approach facilitates a colorful treatment of shadows and defines them, especially in plein air painting. Remember to take into account that shadows can move and change in length during the creation of an outdoor painting.*

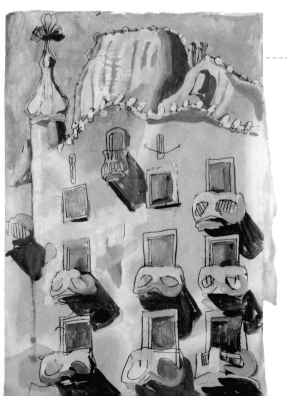

*__Once you understand that the contrast of complementaries creates great tension between the areas of light and shadow,__ you can throw yourself into experimenting with the possible combinations of these two groups of opposite colors. In drawings and contemporary artistic representations, it is common to use vivid color contrasts to add a strong dramatic quality and greater visual impact to the piece. A good example of this effect is shown here with the yellowish warmth of the illuminated areas and the fullness of the violet shadows.*

# Experimenting with Pure Colors

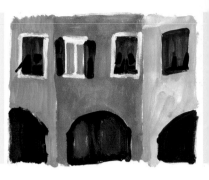

*This model offers few possibilities if we use the real colors. When making a preliminary sketch we can see the chromatic monotony and the overly static feeling of the scene.*

## COMPLEMENTARY COLORS

**1**

**2**

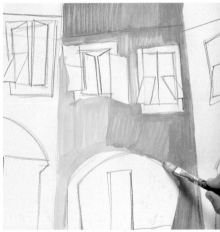

**1.** *Now you can set yourself up for a bolder approach. This drawing is dominated by diagonal lines that destabilize the facades and clearly deform the windows.*

**2.** *The facades are painted with striking colors. The front of the middle house is painted with a fluorescent orange so that it becomes the center of attention, the brightest part of the painting.*

Pure colors are the key element of a composition, and it is important to strengthen them to create strong artistic results, especially when confronted with a monotonous and static model with little chromatic variety. In these situations, reject the austere colors and focus on the strongest ones; create a new model with pure, exciting colors and with a deliberately stylized composition to make a more interesting, dynamic scene. This exercise was created with acrylic paint by Gabriel Martín.

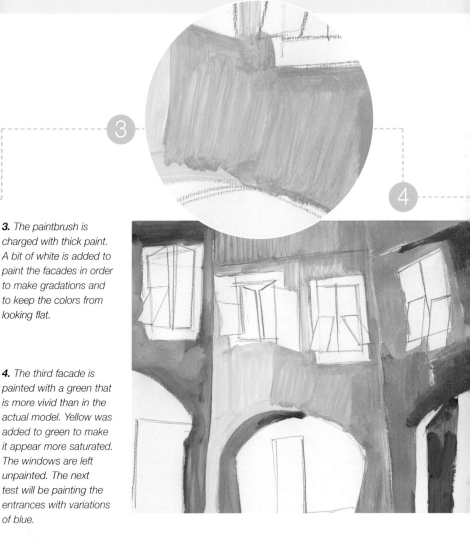

**3.** The paintbrush is charged with thick paint. A bit of white is added to paint the facades in order to make gradations and to keep the colors from looking flat.

**4.** The third facade is painted with a green that is more vivid than in the actual model. Yellow was added to green to make it appear more saturated. The windows are left unpainted. The next test will be painting the entrances with variations of blue.

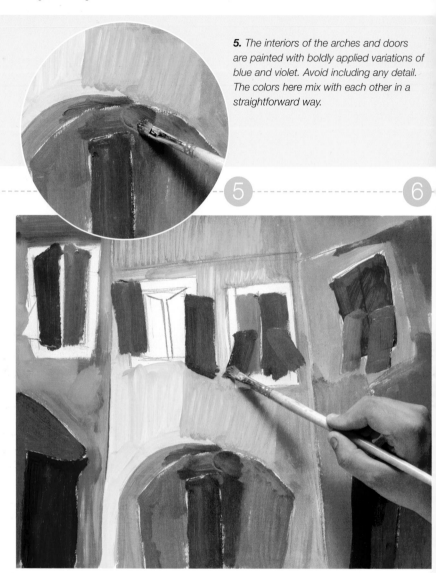

**5.** *The interiors of the arches and doors are painted with boldly applied variations of blue and violet. Avoid including any detail. The colors here mix with each other in a straightforward way.*

**6.** *The windows and shutters are handled in a similar way, although this time the variations of color will be greenish. Each area of overlaid color should be of a different tone from the previous one to create a slight contrast.*

**7.** *Next, a fine round brush is used to add greater graphic interest to this painting made up of vibrant, unrealistic colors. Outlines are drawn and details are added to the sign. The addition of the lettering is reminiscent of the way the Cubists used graphics.*

**8.** *The additional lines and outlines are repeated in some windows and in the cables across the facade. The quick drying acrylics allow for accurate brushstrokes without mixing with the color underneath. In the final product, notice how the deformed representation and the contrast of pure ranges of color made the most of the original model.*

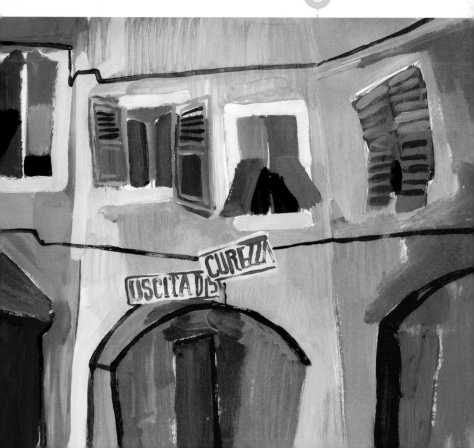

# Psychological Opposites

In earlier chapters you have studied the contrast that exists between complementary colors. For example, a maximum contrast exists visually between magenta and green. However, there is a feeling that there is an even greater contrast between red and blue. How could this be? This impression can be explained by the psychological contrast between complementary colors, that is to say, pairs of colors that strongly contrast with each other according to our perception and our understanding, if not to the scientific theories of color.

**When two psychologically contrary colors are put together,** they can create a visual impact that exceeds their actual intensity, and they can add more energy to the representation. This can be seen in this cityscape painted with yellow and gray.

## Against the Theory of Color

Several studies show that the scientific theory of color and our own perception of color do not completely align. In other words, the feeling evoked by contrasting colors does not always correspond with the way they relate to each other in a technical sense. Therefore, it is important to be aware that there is another way (besides color theory) of understanding strongly contrasting colors.

## The Sensation of Colors

Psychological opposites come from perception, from the senses themselves. They are deeply rooted in universal experiences beginning from infancy, in our language and beliefs. According to various surveys, blue is considered the opposite of red, yellow of gray, green of violet, brown of white, and pink of black. This has no scientific basis, but it is how people all over the world perceive these hues, no matter their education or culture.

*These are some common combinations of psychologically opposite colors* according to surveys done on populations all around the world.

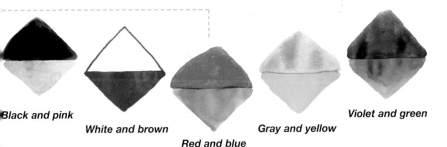

**Black and pink**

**White and brown**

**Red and blue**

**Gray and yellow**

**Violet and green**

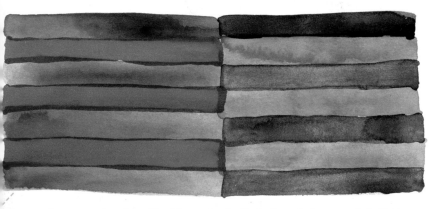

*If you paint two rectangles with stripes of color that alternate two psychological* **opposites,** *you can see how both colors are mutually activated, exactly as happens with contrasting complementary colors.*

# Applying Colors to the Support

When painting a model, the way colors are applied to the support is just as important as the choice of colors. It is important to know the principle techniques, because each one of them affects the final result. The main difference between them lies in the amount of paint the brush can support, in consistency and in the intention of the brushstrokes. Let's look at some examples of the most important of these techniques.

*Grainy brushstrokes that emphasize the texture of the support are made with a barely diluted charge of paint on the tip of the brush.*

*You can mix two colors of diluted paint. The edges between both blend in a gradation.*

*With oil or acrylics the treatment can be thick and opaque. In this case, undiluted paint is used.*

*Striated lines that work well for representing vegetation can be made with the tip of a brush charged with diluted paint.*

*When applying a fresh layer of thick and opaque paint, it can be brushed repeatedly to create mixes between various colors to form gradations.*

*A simple motif like an apple is ideal for practicing the mixing of colors with a dry brush approach. The same subject can be used to do more experiments.*

*Brushing in one direction with undiluted paint creates interesting tonal ranges. The brush should be charged with just a little paint.*

*Impasto is applied with a brush that is heavily charged with paint, forming a creamy surface on the support where the brush marks can be seen.*

*A brush is not always necessary for painting. Paint applied directly from the tube creates a strong relief effect.*

*The application of paint with a palette knife is an approach that gives the painting greater expression.*

# Mixing and Painting

**In this last section we will explore the colors that emerge from the real or imagined mixing on the canvas.** Understanding how colors influence, affect, and interact with each other in a painting allows the artist to predict the results and chromatic effects, to know beforehand all the possibilities of mixing and creating new colors. Studying and controlling mixtures is very important for all artists, since this facilitates their work and gives them better control over the final result of any painting.

# The Painter's Palette

The professional artist usually makes small color notes where they try out mixes and combinations. This way they can evaluate color mixtures and their effects before they deal with the full painting. Before working with the different possibilities of physical or optical mixes available to the paint, we will offer some advice about the use of the palette and mixing with the brush.

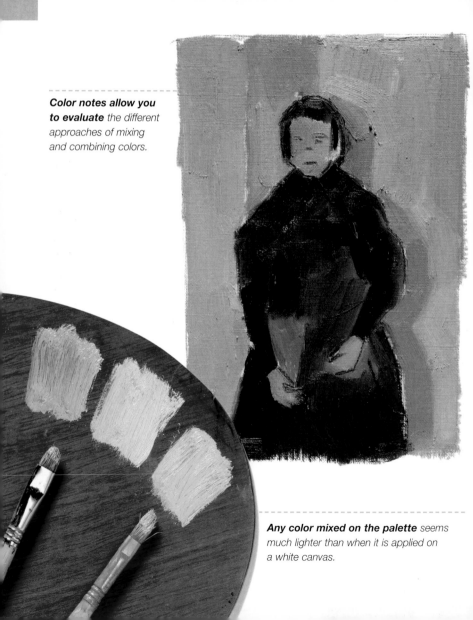

*Color notes allow you to evaluate* the different approaches of mixing and combining colors.

*Any color mixed on the palette* seems much lighter than when it is applied on a white canvas.

## Problems with Mixing on a Palette

When mixtures of color are prepared on the palette, the background can cause some problems. Since wood has a brownish color, it acts on the color that it is applied over it and the mixture can appear deceptive. A color surrounded by dark brown will seem much lighter than if it is surrounded by white or another light color. To check the true range of color you must brush some of it on the canvas.

## Painting with Various Brushstrokes

It is important not to muddy the colors, especially if you are working with light values. Many artists have problems with this because they work with just one brush, which means they have to clean it each time they change colors. The turpentine or water becomes cloudy and the brushes along with it, making them incapable of maintaining a perfect yellow or white greenish-gray tint. The answer to this problem is to have a brush for each color.

**Alla prima** *painting consists of mixing the colors directly on the surface of the painting. This technique requires a limited palette of about eight colors, since more than that would be difficult to coordinate.*

**To avoid muddying colors when mixing,** *it is best to have a separate brush for each color.*

# Neutral Colors

The neutral color range is created by mixing two complementary colors with each other. The results of these mixtures offer a range of gray and brown tones that look somewhat muddy compared to pure colors.

## How to Achieve Neutrals

Neutral colors are the result of mixing two complementary colors, for example: red and green, blue and orange, or yellow and violet. If the mixture of these complementary colors is created in equal parts, that is to say,

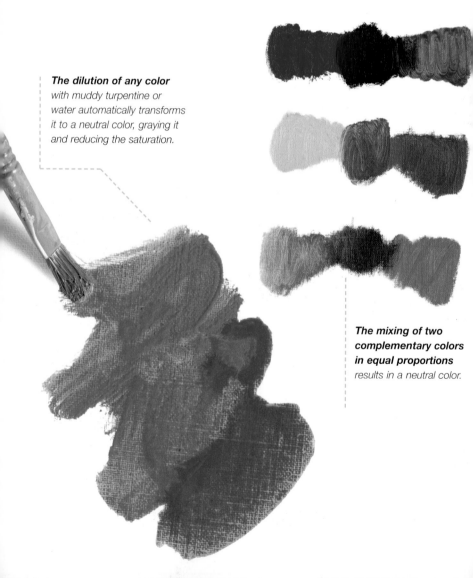

*The dilution of any color* with muddy turpentine or water automatically transforms it to a neutral color, graying it and reducing the saturation.

*The mixing of two* **complementary colors in equal proportions** *results in a neutral color.*

### Adding White

It is a good idea to mix complementary colors in unequal proportions to obtain cleaner neutral colors, and to then add white to them to reduce the graying of the color. Since the mixtures of neutral colors tend to look cloudy, the addition of white lends them more light and in a way "cleans" the colors.

a 50/50 mixture, you get a pure neutral. Combined in unequal parts, you get neutral colors with tendencies toward one or the other complementary colors. Another way of creating a neutral is to mix any color with gray, brown, or another neutral color.

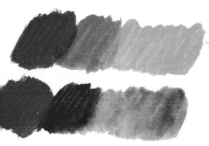

*Neutral colors are mixed with different amounts of white to create a range of values of a certain tone.* This allows you to develop an unlimited range of shades.

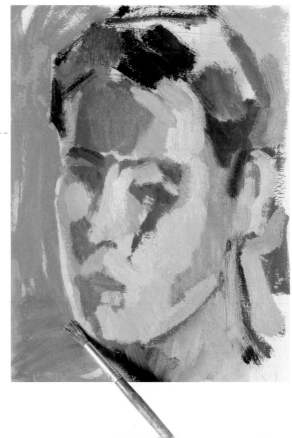

*At first glance, a painting with neutral colors can look monotonous.* However, if the colors are applied skillfully, a painting will show signs of clever effects and artistry, because the grayed tones will help eliminate any loud colors and tone down contrasts. Furthermore, the neutral range is the most extensive one, and it gives the artist the most variations of color to work with.

# Glazing over a Colored Background

Thanks to glazing, you can enrich the chromatic range of any color. By superimposing one transparent layer of paint over another, the color perceived is a mixture of the base color and the color of the glaze. If the tone of the glaze that you

*You can superimpose a glaze of a color that is very close or in the same range to obtain a deeper blue.*

*With glazes, the mixing of colors is done on the canvas. Thus, a yellow glaze over a blue base produces green.*

*It is always best to use glazing of similar intensity, and to apply the lighter color over the darker one.*

*All glazing, no matter how watered down and transparent, modifies the tone of the underlying color.*

applied is in the same color range as the underlying paint, the final color will be decidedly darker. On the other hand, if the color of the glaze is very different from the one that is under it, the result will be a completely new and more translucent complementary color.

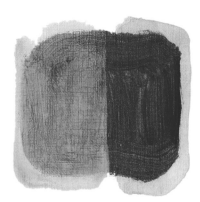

*White glazes reduce contrast and lighten the base color. They are very practical for lightening and diminishing a color.*

*Each layer of glazed color intensifies the previous layers. The superimposition blocks the light reflected by the white of the paper.*

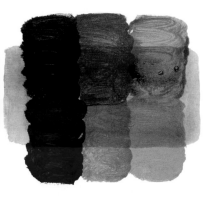

*This transparent blue glaze is applied over six brown tones. Notice how it has a greater effect on the light browns than on the darker ones.*

*Three should be the maximum number of layered glazes; a greater number nullifies the colors and muddies them.*

THE SUBJECT

# High-key and Low-key Colors

The terms *high key* and *low key* normally refer to the brightness and saturation of colors. In low-key paintings, vivid colors and contrasts are characteristic. In high-key paintings, contrast and harshness are reduced, with the aim of creating an extremely pleasant whole.

*Low-key paintings are full of expressive colors that are barely mixed. They offer an excellent opportunity to work the surface of a work with colors that hold their purity, and to create areas of heavy paint with lively brushstrokes.*

*Low-key colors are saturated and they rarely look mixed.*

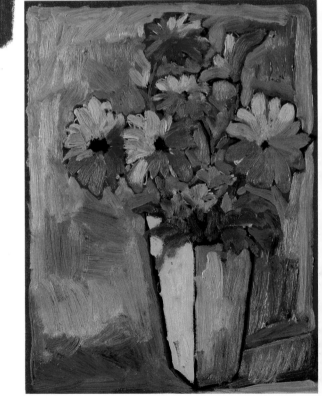

## Low Key

In low-key ranges, colors are not toned down; on the contrary, they are applied in much more saturated color ranges, or in modulations that contain a lot of black (in monochromatic pictorial treatments). Landscapes that are strongly illuminated by the sun are usually resolved with a low-key range of colors, as is a nocturnal subject where black is the dominant color.

## High Key

In a high-key painting color ranges where the values contain a lot of white are used. For example, for a snowy landscape or one that is plunged in a thick fog, the artist will need to use a high-key range—each mixture of colors should be reduced with white. The neutrality that white lends to colors harmonizes them and gives them extraordinary strength. High-key paintings might seem less colorful, but they can be very delicate and subtle.

**High-key colors appear whitish.** *They are lighter and possess an extraordinary harmony.*

**In paintings made with high ranges, the modulations of value and saturation** *are mixed with a lot of white to temper the colors.*

# Vibrating Colors

An accumulation of small brushstrokes, applied even on a small surface, will allow for a great variety of colors and tones, giving the surface color a vibrant appearance. The closely-spaced, repeated colors create an optic combination that simulates the effect of a solid color surface.

**The effect produced when a superimposed color only partially conceals what is below it is a form of optic color combination.** *For example, if a layer of red is spread over a green background, it will create an effect similar to what you get with juxtaposed dabs of paint.*

**Optical mixing** *is created by building up the surface color with the smallest of units, the brushstroke.*

**If the superimposed brushstrokes are made with fresh paint,** *the brush picks up the color underneath, causing physical mixing.*

## Tiny Crowded Brushstrokes

The painter applies small individual dabs of color on the canvas, and then it is up to the viewer's retina to perceive a given color surface. Areas with two or more similar colors near each other seem to blend in the viewer's eye, creating a new color and a very bright, lively effect. Even on small surfaces, the entire range of colors can be built up with tiny brushstrokes, giving off intense light and movement that is even greater than in the colors previously mixed on the palette.

## Don't Paint with Dark Colors

To make the most of color with this technique, only light and saturated ones should be used: that is, primary and secondary colors directly from the tube or mixed with white. Darker tones and black must be avoided.

*The bits of color are optically mixed in the painting* to produce much more intense colors than any of the originals previously mixed on the palette.

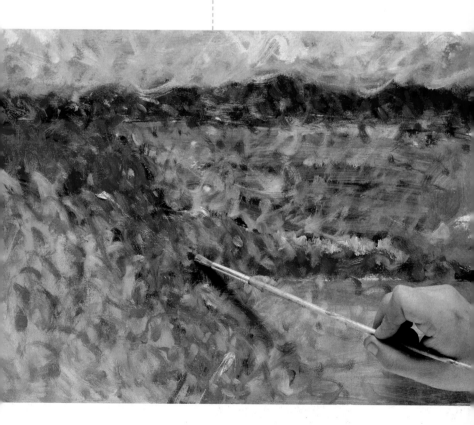

# Activating Complementary Colors

Two complementary colors, opposite each other on the color wheel, have an interesting love-hate relationship. They are opposed to each other, but at the same time they demand the other's presence. Colorist painters make the most of this mutual activation to create works with impassioned colors.

*The spatial distribution of complementary colors has the most impact if one pays attention to their amounts of luminosity.* Since red is more luminous than green, it will always be more suitable for representing light, and green for representing shadows.

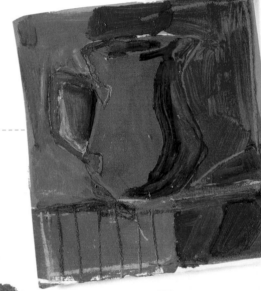

*When two complementary colors are next to each other,* both seem brighter.

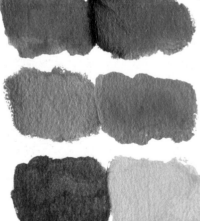

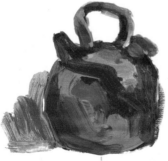

*The contrast of the split complements,* orange and violet, is similar to what happens with complementary colors.

## Combinations of Complementary Colors

In a painting that uses complementary colors, you can create strong tonal vibrations between colors without upsetting the harmony of the work. They offer the best opportunities for creating contrast, although they can be visually harsh. To achieve maximum harmony, it is important that one of the colors is pure, and the other is modulated with white or black. Alternately, instead of the complementary colors, you can use the tones created by mixing the two to unite them.

## Clean Your Brushes Well

When you are working with saturated colors, it is important to keep your brushes clean, especially if you are using light colors like yellow or orange. Be sure to rinse the brush well with turpentine and clean it with a cloth before using new colors.

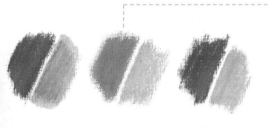

*Split complements are pairs of colors that produce sensations similar, but more toned down, to those of complementary colors* green and orange, orange and purple, or green and purple.

*Split complements, painted one next to the other, generate very vivid and impassioned color contrasts,* similar to those created with complementary colors.

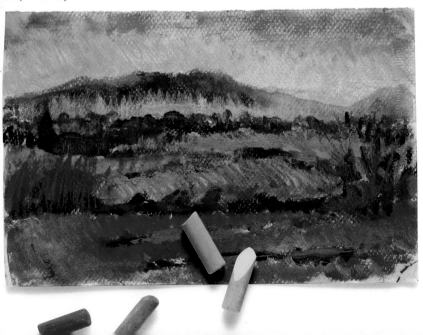

# Claude Monet
## (1840–1926)

He was perhaps the most impressionistic painter of anyone in the group in Paris during the last quarter of the nineteenth century. His work is distinguished by a clear effort to paint light with overlaid brushstrokes, without losing the essence

**Haystacks in the Morning** and **Haystacks at Dusk** *(both from 1891) reflect Monet's interest in the light that bathes a landscape. Painting a landscape means painting natural light, which undergoes constant changes subject to the position of the sun and state of the weather. Monet often illustrated this fact by painting the same motif in different atmospheric and light conditions: under a torrid sun, at dusk, with snow, and so on. Each one of these moments gave the artist the opportunity to represent the model with different light conditions.*

THE TRANSITOR

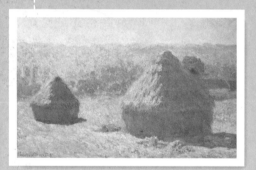

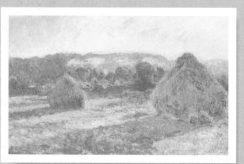

*1. We can emulate Monet and choose the same motif to study the different conditions of light throughout the day and see how the changes affect color. We begin with a representation of a rocky outcrop on a coast in the early hours of the day. The weak light mitigates the blue of the ocean and sky and creates a world of neutral colors—browns and greens mixed with white.*

of the colors that are emphasized in the finished work. This French painter carried the study of the transitory states of natural light

to its fullest expression. His outdoor experiments showed great audacity, since they tried to reproduce the effect of light on the landscape through a loose application of short and vigorous brushstrokes of bright color. His technique is based on the speed and spontaneity that plein air painting demands.

-----------------------------------------

*Claude Monet is often considered the greatest painter of landscape light.*

**ESSENCE OF LIGHT**

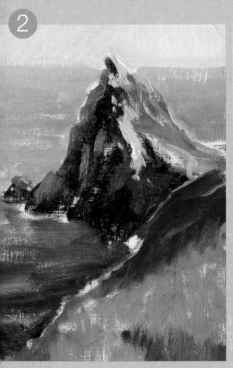

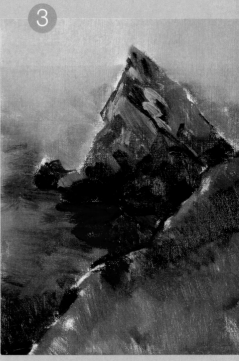

**2.** *Here is the same rocky outcrop painted when the sun is at its highest point. It is a spectacle of luminous greens blended with orange. The ocean is a very intense blue and the shadows of the rock are somewhat violet. The contrast between the illuminated zones and the shadows should be very strong, since it is the main indicator of the sunlight's direct rays.*

**3.** *With the setting of the sun, the ocean darkens. Do not forget that the ocean is a mirror of the sky. The rock is completely bathed in shadow, and violets and blues dominate the colors of the painting. There is little contrast; the landscape is submerged in a tonal homogeneity. (Exercises painted by Gabriel Martín.)*

# A Still Life with High-key Colors

*Despite its simple composition, this scene offers many possibilities. In this exercise by Gabriel Martín he attempts to synthesize to capture the essentials.*

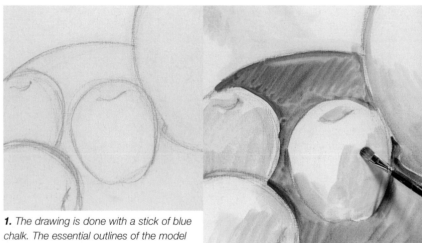

**1.** The drawing is done with a stick of blue chalk. The essential outlines of the model are expressed with circular forms, which have been slightly distorted to add a little more life and expressiveness, breaking up the excessive stillness of the model.

**2.** Ultramarine blue diluted with turpentine is painted over the outlines of the apples and of the jug, diluting the blue chalk lines. This same color is used to paint the table and apply the first shading on the fruit. This is a good base for starting the painting.

In the next exercise we paint a still life, controlling the harmony of the colors with a high-key range. In other words, we will reduce the saturation of each color with a little white. The whitened colors reflect more light; they sometimes make things appear larger and less heavy. They also create the illusion that everything is bathed in a more homogeneous light, which imparts a happy feeling.

*3. The first step is to address the lightest areas of the painting, in this case the jug on the right. It is painted with a gradation that goes from gray (in the lower part) to white (in the most illuminated zone). The white is cooled with a bit of cyan.*

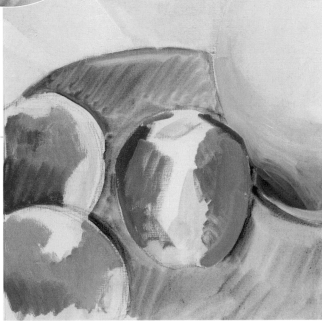

*4. Each area of the painting has a corresponding zone of light flat color. First we begin painting the apples, but instead of using a saturated red straight out of the tube, the red is reduced with white, which tempers its initial brightness.*

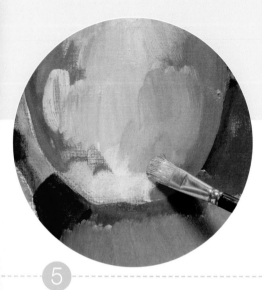

**5.** Colors should first be mixed on the palette, with more or less white depending on the amount of light you desire. Then they are blended with their adjacent colors from the color wheel to create a sense of the apples' roundness.

**6.** Each brushstroke is a dab of color that contributes towards completing the pieces of fruit and the light that falls on the table. The range of colors used goes from whitened gray to blues and violets on the table, and ochers, oranges, and yellows on the apples. The reflection of the fruit is painted on the surface of the jug with violet tones.

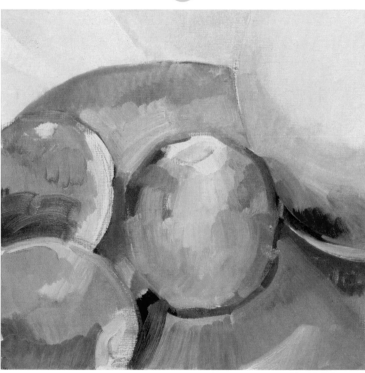

**7.** *The forms of the apples are completed with applications of ocher and yellow mixed with white. The paint is creamy so that the brush marks are evident, which will make the painting more interesting.*

**8.** *In the finished painting, you can see that the treatment has been very stylized, with barely three or four areas of color indicating the form of each piece of fruit. Despite the color blue that surrounds the apples, the addition of white in the mix tones down its saturation, so that the apples, which are also lightened, harmonize better with the background.*

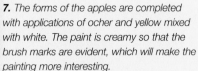

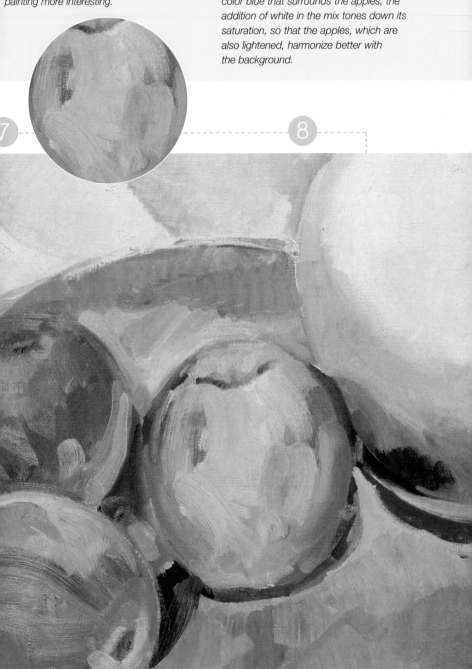

# Shiny Colors: Fluorescent, Pearlescent, and Metallic Paints

Oils and acrylics, in addition to the range of traditional colors, also come in different types that are related to the way in which light is reflected on the particles of pigment. The best-known variations are gold and silver metallics, mother of pearl or pearlescent paints, and fluorescent colors.

*Fluorescent colors* are very common acrylic paints.

*Fluorescent and metallic colors* not only attract the viewer's eye, but also to hold their attention longer.

## Gold and Silver

These colors add a lot of warmth to paintings, and they are usually associated with the richness of precious metals. Gold combined with dark grays or purple harmonize, and combined with fuchsia or orange appear festive and sophisticated. Silver, on the other hand, relates better to the cool color range.

## Pearlescent or Iridescent Colors

These have a pearly sheen that changes according to the way that light falls on the paint and the angle of vision. They are made with flakes of mica mixed with titanium. A drawback is the very limited range of available colors.

## Fluorescent Colors

These are extremely loud colors that seem to light up by themselves. This is because conventional pigments reflect part of the light and absorb the rest in the form of heat. Fluorescent paint, on the other hand, absorbs light rays in a spectrum and reflect it again as visible light in other bands of the spectrum. When we see a greater amount of light than expected, it seems like the pigment shines by itself.

*Since the range of pearlescent colors is very limited,* it is best to buy a pearlescent medium instead and mix it with each color as needed.

*Some artists buy tubes of gold, silver, and pearlescent paint* to add a distinct sheen to traditional colors.

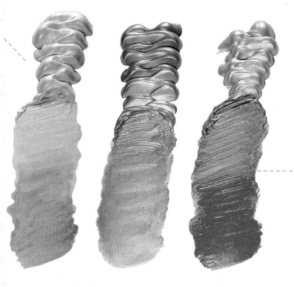

*Gold and silver paints are usually combined with other traditional colors* to create colors that seem more solid and bright.

# Polychromatic Colors

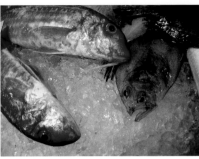

*The model is a still life of a group of fish. The reflection and luminescence of the scales and ice stand out.*

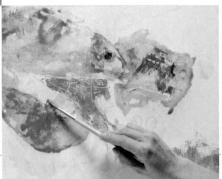

**1.** *Glória Valls draws all the fish on the bed of ice using a 2B pencil. A first application of fluorescent fuchsia mixed with orange is added to the fish on the left with a metal palette knife.*

**2.** *The shaded areas of ice are painted with a silvery-gray, and sgrafitti is made with the tip of the palette knife. The washes on the sides of the fish suggest the texture of the scales, as do the small spots of fluorescent orange paint.*

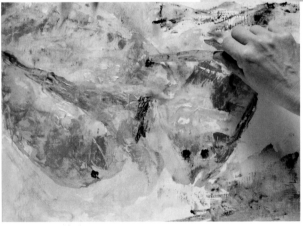

**3.** *Silver and gold paint is dragged across the ice with the palette knife. These colors shine and create reflections that appear or disappear depending on the position of the viewer. The eyes of the fish are suggested with the tip of a palette knife and ivory black.*

There is a growing trend among contemporary artists to use gold, silver, and fluorescent colors to create new chromatic effects in their paintings. In this exercise with acrylics, these paints are combined with traditional colors to accentuate chromatic areas or to reinforce the forms in order to create a modern and actual interpretation.

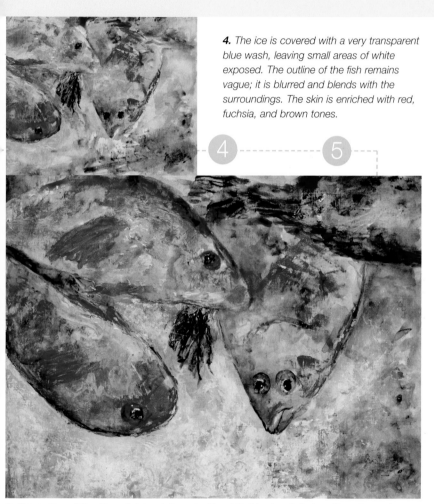

*4. The ice is covered with a very transparent blue wash, leaving small areas of white exposed. The outline of the fish remains vague; it is blurred and blends with the surroundings. The skin is enriched with red, fuchsia, and brown tones.*

*5. The outline of the silvery fish is reinforced with subtle blue brushstrokes. Then the scales are finished by applying small bits of color, altering the silvery and fluorescent colors. The areas with the most light are painted silver, as is the surface of the ice though in an irregular way.*

# Color and Abstraction

Abstract forms completely disassociated from the real model, are born of the artist's imagination and fantasies. They emphasize the chromatic, formal, and structural aspects in the work, accentuating them to bring out their expressive value and strength. Abstract paintings should not be interpreted the way the themes in a realist or figurative painting are; they must be felt.

*Any element can be converted into an abstraction, from a simple collage to a few meaningless brushstrokes.*

*In order to control color combinations and use them to create the most effective contrasts and mixtures, it is essential to have a plan for the work and improvise as little as possible.*

## A Surface of Color

Abstract art does not favor the distribution of colors over the form, and it often replaces the form with an autonomous visual language. This is based on a change in the concept of the painted surface—no longer just a simple window in which a subject is represented in three dimensions, but rather a flat surface whose purpose is to provide a space to experiment with color.

## Color Has Limitations

Limitations of color exist in all abstract art; they are based on the real danger of exhausting the possible color combinations and falling into repetition. So how do you continue to create variety in an abstract representation? How do you differentiate one style from another? The innumerable representations across abstraction are nourished by graphic variety and the various methods used to apply color to the canvas: brush gestures, dripping, splashes, stains, impasto, and so on.

**The different techniques for applying color on a painting are important in defining the work.** *This one was done with dripping.*

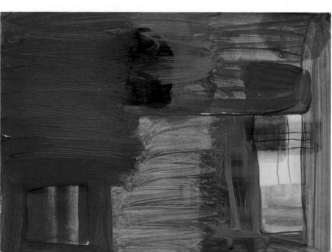

*In abstract painting, artists reduce the representation of a form to the bare minimum so that colors can be manipulated as they like.*

IN THE STYLE OF...

# Nicolas de Staël
## (1914–1955)

This Russian painter, who became a French citizen, is known for his daring use of colors, his ability to synthesize, his use of heavy impasto, and his intensely abstract landscapes. His most characteristic pieces date from after 1950, the year he began creating his paintings with a radical abstract technique. He would apply spontaneous brushstrokes and leave large spaces covered in a thick coat of oil paint, with colors that were barely mixed, and in some cases, applied directly

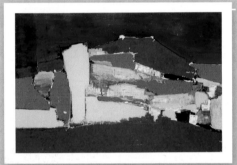

**The Mountain of Sainte-Victoire**
*(a Sicilian landscape), 1954. Staël painted energetic landscapes that show a free use of colors, especially pure and bright ones. His Sicilian paintings recall the experiments with colored paper that he created before his trip to Italy. The colors confront each other boldly, disregarding all harmony and dissonance.*

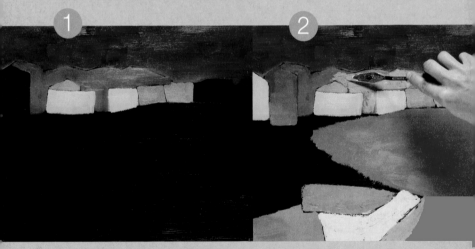

*1. The representation of this small fishing port was done by Glória Valls, imitating the technique of Staël. The paper was covered with black acrylic paint. When it was dry, the sky was covered with a medium intensity violet. The facades of the houses in the background are synthesized with saturated colors, very uniform and barely mixed.*

*2. The first areas of color were done with a flat hog bristle brush, but as the painting advanced a palette knife was used to apply the layers of color and break the excessive sameness of each application. The entire landscape was constructed as if it were a puzzle.*

from the tube. His work reflected a struggle and tension between figurative painting and abstraction. The artist fearlessly combined intense colors. No combination seemed impossible to him. This is why, in his paintings, colors boldly and sumptuously play off of each other.

*Nicolas de Staël saw the landscape as basic units of color.*

# THE BOLD USE
# OF COLORS

**3.** *Sometimes the areas of color touch the ones next to them; other times, a small space is left between them—a thin line highlighted against the darkness of the background. This creates a network of colors and lines that strongly organize the composition. The work ends up saturated with audacious colors.*

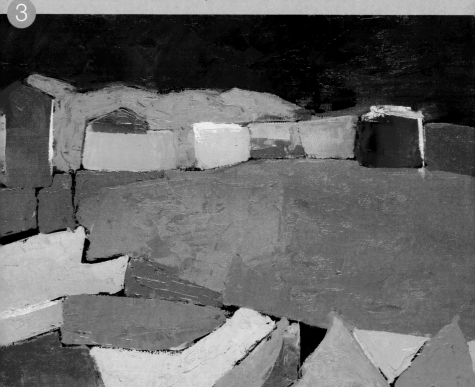

*"The chief function of color should be to serve expression as well as possible ...
The expressive aspect of colors imposes itself on me in a purely instinctive way."*

Henri Matisse